The

Senior's Guide
to Digital Photography

Shoot, Edit, Print or E-Mail Pictures

A Gift from
Be the Star You Are®! Non Profit
PO Box 376
Moraga, Ca. 94556
877-944-STAR
www.bethestaryouare.org

The

Senior's Guide
to Digital Photography

Shoot, Edit, Print or E-Mail Pictures

By Rebecca Sharp Colmer
and
Todd M. Thomas

EKLEKTIKA PRESS
Chelsea, Michigan

EKLEKTIKA Press
P. O. Box 157
Chelsea, MI 48118

Library of Congress Card No: 2004092901
ISBN: 0-9651672-5-9 Softcover
Printed in the United States of America

To Flip

"Teachers open the door, but you must enter by yourself."
Chinese Proverb

ACKNOWLEDGMENTS

Thanks to:

Flip Colmer, who is brilliant and charming. You are a remarkable person. Thank you for your continued assistance.

Thanks to:

Kim Thomas, you are the one who makes this possible. Abigail and Ben Thomas for understanding and giving me the time to write.

Thanks to:

Malcolm Colmer, Ruth Bell, Ron Steblea, Sue Bowen, Tim Zulewski, Jan Sevde, Dave Brichetto, Michael Cody, Robert Rohm.

Thanks to:

The aging Baby Boomers and Seniors.

Table of Contents

Table of Contents

Table of Contents

Table of Contents

Table of Contents

Table of Contents

Table of Contents

DISCLAIMER

Every effort has been made to make this book as complete as possible and as accurate as possible. However, there may be mistakes both typographical and in content. Therefore, this text should be used as a general guide and not as the ultimate source of information.

Trying to keep up with the ever-changing computer technology and the Internet is nearly impossible. If you find something that is not right, please let us know via e-mail by visiting our Web site at **www.theseniorsguide.com**.

WELCOME TO DIGITAL PHOTOGRAPHY

We have reached the time when having a computer is almost as common as having a telephone, and just as necessary. Just as word processors changed writing, digital imaging is revolutionizing photography.

Congratulations! Welcome to the digital world. You are going to feel "right at home" in no time at all.

ABOUT THIS BOOK

This "user friendly" handbook will help the person who wants to learn the basic facts about using a digital camera. You will be introduced to the tools and techniques to make you look like a "pro."

This book is intended for a novice or new digital photographer. However, an experienced user will find it helpful, too.

As much as possible, this book will try to make your digital photography experience easy and fun.

Smile! Say "cheese".

Enjoy!

OBJECTIVES AND LIMITATIONS

Let us make one thing clear right at the beginning. This book is not a textbook on how to learn everything there is to know about digital photography.

Instead, it is an organized collection of fundamentals geared toward getting you going fast!

This book was written from the perspective of a Windows XP user. Windows XP includes basic photo-editing tools. Just as you can purchase a digital camera with more buttons and features, you can buy more advanced photo-editing software.

But here is the good news. You do not have to buy advanced photo-editing software in order to get started. And you do not have to have Windows XP to get started. You can use a different version of Windows, a Macintosh computer, or no computer at all!

WE WANT TO HEAR FROM YOU

Send us a sample of your best shots. Who knows, we may post it on our Web site.

Send us your questions.

Visit our Web site at **www.theseniorsguide.com**

Or

You can always contact us the old fashioned way:

The Senior's Guide
EKLEKTIKA Press
P. O. Box 157
Chelsea, MI 48118

Introduction

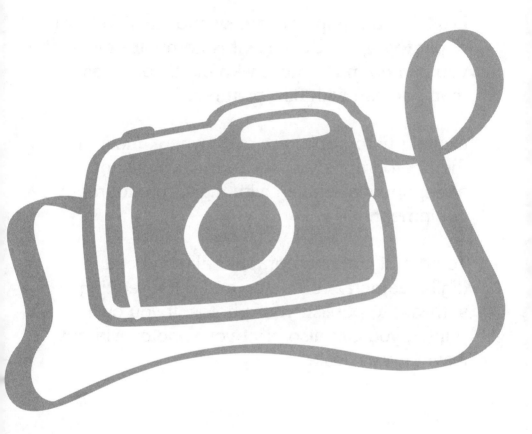

In this first section we briefly introduce digital photography: what it is, why you should learn it, some pros and cons, and the skills you need to get started.

WHAT IS DIGITAL PHOTOGRAPHY?

Digital photography is a new and exciting form of photography. Because it is computer-based, you can do much more with digital pictures than you can with film pictures.

Digital photographs are everywhere. Most of the photographs you see in magazines and newspapers are taken with digital photography equipment.

To be a digital photographer all you need is a digital camera, computer, and photo-editing software to publish your photos. If you own a printer, you can also print your photos without leaving your desk.

WHAT IS THE DIFFERENCE BETWEEN FILM AND DIGITAL PHOTOGRAPHY?

The primary difference between film and digital photography is:

Digital photography does not use film!

So what does this mean?

This means you instantly have your picture when you use a digital camera. Unlike a film camera, you do not have to use the whole roll of film and take it down to the developer before you get to see your family reunion pictures.

With a digital camera you get to see your handi-work within seconds!

WHY SHOULD I LEARN DIGITAL PHOTOGRAPHY?

So what is the buzz about digital photography? All my friends talk about it. My kids use it. But why should I learn digital photography? What's wrong with good ol' film cameras?

First of all, nothing is wrong with film cameras. In fact, most professional photographers still claim that film cameras produce higher quality photographs. This fact is disputable given the wide use of digital photography equipment in the professional media.

Despite the debate, digital photography opens new and exciting ways for you to take and use photographs. For example, with a digital camera you can:

- Send pictures of your grandchildren to your friends via e-mail.

- Post pictures on eBay to sell things.

- Store 1000's of pictures on your computer.

- Change the way the picture looks if you don't like the original image.

ADVANTAGES OF DIGITAL CAMERAS

The list below illustrates only a few of the many advantages of a digital camera.

- You can take as many pictures of a subject as you want just to make sure you get the perfect shot.

- You can print as many pictures as you want for a small cost.

- You can store the pictures digitally so you can use them in e-mail, documents, photo name badges, and much more.

- Digital cameras now cost about the same as film cameras.

- Pictures are not permanent, so you can delete the ones you don't like.

DISADVANTAGES OF DIGITAL CAMERAS

Digital cameras have some drawbacks. For example:

- You need computer equipment and software if you want to view, edit, e-mail, or publish your photos on the Web.

- You need a printer if you want to print your photos at your desk.

- Digital photography has a learning curve. You must learn how to use a camera and the software. However, the shutter button still works the same.

- You must use special paper to print your pictures to make them look spectacular.

WHAT SKILLS DO I NEED
TO GET STARTED?

Getting started in digital photography is easy, but you do need a few basic skills.

Digital photography can be as easy as "point-and-shoot", but you can do a lot more too!

Of course, the more you know about cameras and photography, the easier you will find digital photography.

In this book we try to introduce basic digital camera and photography concepts. You should also have some basic computer skills, in particular, a familiarity with Windows, sending e-mails, and printing documents on a printer. That's about it. (You did buy, read and study *The Senior's Guide to Easy Computing*, didn't you?)

Now let's get started!

WHAT EQUIPMENT DO I NEED TO GET STARTED?

Getting started in digital photography is easy. Photo 1 (page 27) shows the basic pieces of equipment you might find in a digital darkroom. You will need the following:

- A digital camera, which is a filmless, computer-based camera that stores the pictures in its *memory*. Contrary to what you might think, you don't need to spend a lot of money to get a good, versatile digital camera.

- A computer and photo-editing software to view, edit, and print your pictures. If you purchased a home computer within the last two years, chances are that it has enough power to work with digital pictures. More than likely it has some photo-editing software already installed.

- A printer, if you want to print your pictures so you can display them. Most color inkjets do fine. The real secret to printing digital pictures is the paper.

You do not necessarily need a printer for digital photography. You can take pictures, but not print them. E-mailing pictures provides a quick and inexpensive way to share your photos.

EXAMPLE OF A DIGITAL DARKROOM

Inkjet
Printer

Digital
Camera

Computer

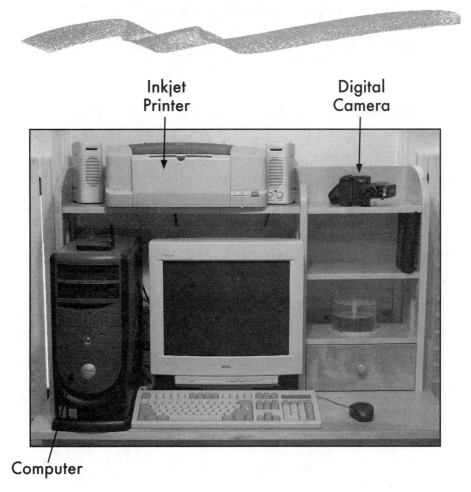

Photo 1: A complete digital darkroom.

DIGITAL PHOTOGRAPHY —
THE BOTTOM LINE

Picture taking just got a lot easier. You will probably agree that digital photography is one of the best new inventions. If you are prepared to learn a few new skills, the entire process of making pictures can rest squarely in your own hands. Digital photography gives you the chance to make your pictures come out just the way you want.

Understanding Digital Cameras

In this section we provide you with some basic information about digital cameras. After reading this section you will not be an expert, but you will know enough about digital cameras to start shopping for one!

HOW DOES A DIGITAL CAMERA WORK?

Digital cameras work much like film cameras. Both take light from an image and transfer it onto some surface. In a film camera, the surface is obviously film.

Digital cameras don't use film. Instead they use an *image sensor,* which is a small photo-sensitive device. The image sensor converts the light into a digital image, and then stores it in the camera's memory. In a digital camera, the memory is the film.

The details of how the image sensor and the camera's memory work are not important. Just know that digital cameras don't use film, but use an image sensor and memory to create an image.

WHAT ARE THE BASIC PARTS OF A DIGITAL CAMERA?

At first glance, a digital camera may appear as complex as your computer. The camera may have a lot of knobs, dials, and buttons.

Photos 2–5 (pages 32–33) provide pictures that identify the major parts of a digital camera. As you read this section refer to the pictures to get an idea of what a certain part looks like.

PHOTOS OF A DIGITAL CAMERA —
TOP AND FRONT

Mode
Controls

Control
Panel

Shutter Release
Button

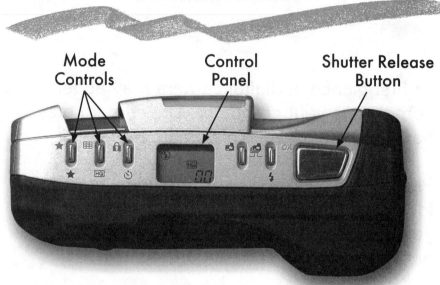

Photo 2: The top of a typical digital camera.

Flash

Viewfinder

Lens

Self-Timer
Light

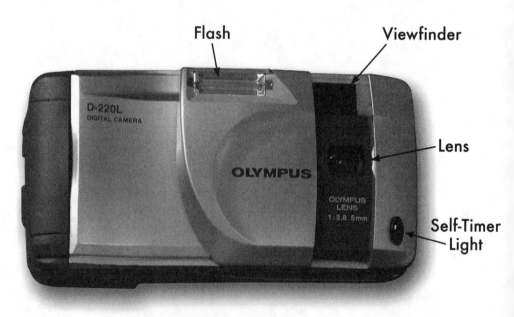

Photo 3: The front of a typical digital camera.

PHOTOS OF A DIGITAL CAMERA — BACK AND SIDE

Viewfinder LCD Battery Compartment

LCD On/Off

Menu Controls

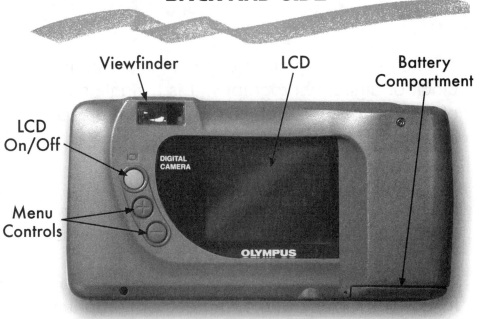

Photo 4: The back of a typical digital camera.

Video Out

Self-Timer Light

Direct Connect Cable Port

AC Adapter

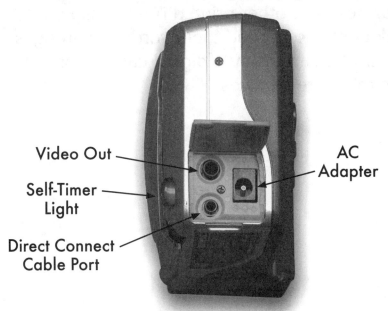

Photo 5: The side of a typical digital camera.

WHAT IS A PIXEL?

A *pixel,* short for picture element, is the building block of digital photography. It is a single square of a single color. Combining millions of pixels together makes a digital picture.

You may not realize it, but you look at pixels all the time. Digital photography is not the only technology that uses it. Other technologies use pixels to create images.

If you look closely at a TV screen or computer monitor, those little dots are pixels. Newspapers, magazines, and other printed media also use tiny dots of ink to build their words and images much in the same way a digital camera uses pixels to create pictures.

WHAT IS RESOLUTION?

The *resolution* of a picture refers to its *pixel count*, or how many pixels it has. *High-resolution* pictures have a high pixel count, while *low-resolution* pictures pixels have a low pixel count.

Resolution is referred to in two different ways. The first is *output resolution*, which refers to the resolution of an image you print. We cover printing in Part 6 — Publishing and Printing. For now just remember that output resolution refers to printing — or getting your image out of your computer.

The second way is called *image resolution* and refers to the picture size as it appears on your computer screen. Image resolution is usually measured by *pixel dimensions*: 640 x 480, 1024 x 768, etc.

Digital cameras generally have several different resolution settings, which range from low to high. You set the image resolution before you take the picture.

WHAT IS PIXEL COUNT?

Pixel count refers to the number of pixels on a digital camera's image sensor. The greater the pixel count, the higher resolution of pictures that you can take.

Image sensors have millions of pixels. Manufacturers list the number of pixels the image sensor has as *megapixels* (mega means 1 million). Lower-end cameras have less than 2 megapixels while the higher-end cameras have 6–8 megapixels. Most consumer grade cameras have image sensors with a 2–3 megapixel resolution.

Remember, the more megapixels an image sensor has, the higher resolution of pictures you can take. However, the more megapixels, the more it costs!

WHAT ARE PIXEL DIMENSIONS?

The pixel dimensions of an image, refers to the resolution of a digital picture. It is the number of pixels "wide" by the number of pixels "high" of a picture.

Manufacturers often list a camera's resolution in pixel dimensions. Below is a list of common pixel dimensions ranging from very low to very high for consumer-grade cameras. We also provide the megapixel count for the common pixel dimensions.

Pixel Dimensions (width x height)	Megapixels
640 x 480	0.3
1024 x 768	0.8
1280 x 960	1
1600 x 1200	2
2048 x 1536	3
2272 x 1704	4
2560 x 1920	5

WHAT IS THE DIFFERENCE BETWEEN HIGH-RESOLUTION AND LOW-RESOLUTION PICTURES?

High-resolution pictures are very clear and have very sharp edges. On the other hand, low-resolution images can be blurry and dull looking.

High-resolution pictures have very large pixel dimensions. High-resolution images have pixel dimensions of 1280 x 960 or greater.

Low-resolution pictures have smaller pixel dimensions. Low-resolution images have pixel dimensions of 1024 x 768 or less.

WHY IS RESOLUTION SO IMPORTANT?

Resolution determines the detail and size of a picture. As mentioned before, the higher an image's resolution, the sharper and clearer the image.

High-resolution pictures require more memory because they have more pixels. High-resolution images also require a lot of computer power to manipulate and they require more storage space on your hard drive. It also takes longer to e-mail high-resolution photos.

Do not think you should only use high-resolution pictures. Low-resolution images have some advantages over high-resolution images.

Low-resolution photos have fewer pixels resulting in smaller file sizes. As a result, low-resolution images require less memory, which allows you to store more photos on your computer and camera, and send photos more easily via e-mail.

You typically use low-resolution images for e-mailing and displaying them on the Internet. You use high-resolution images when you want to print an image.

However, when taking a photo, you should always shoot in high resolution to capture the most detail. You can always reduce the resolution when the need arises. You cannot add resolution to a low-resolution photo.

The chart below shows pixel width and height needed to print a digital photo at 300 *dpi* (dots per inch). Remember, you can print an "okay" 4 x 6 print from digital images that measure less than 1200 x 1800 pixels, but the print resolution will be less than 300 dpi.

Print Size	Width Pixels	Height Pixels
4 x 6	1200	1800
5 x 7	1500	2100
8 x 10	2400	3000

WHAT IS MEMORY?

A digital camera stores pictures in memory. In essence, memory is the film of the camera.

The memory on a digital camera is very similar to the *RAM* in your computer. Just like on your computer, the memory for a digital camera comes in various sizes. Memory is available from 1 MB to over 1 GB.

Memory impacts the number of pictures you can store on a digital camera. The more memory in the camera, the more images you can store.

WHAT TYPES OF MEMORY DOES A DIGITAL CAMERA USE?

There are two types of memory used in digital cameras: *on-board memory* and *removable memory*.

On-board memory is permanently mounted in the camera. If you fill the camera's memory, then you cannot take any more pictures. You must delete, or transfer them to a computer, before snapping any more shots.

Removable memory is a type that you can take out of your camera. Unlike on-board memory, if you fill this type you can take it out of your camera and put it in empty memory.

Both permanent and removable memory are re-writeable memory. You can use it again, once you transfer or delete the stored images.

Removable memory is stored in your camera's memory compartment. The type of removable memory that you can use depends on your camera.

WHAT ARE THE DIFFERENT TYPES OF REMOVABLE MEMORY?

You will encounter several different types of removable memory when shopping for a digital camera. Photo 6 (page 44) shows some of the different types. The camera you buy will likely use one of the following:

- **CompactFlash Type I** — This is the most common type of removable memory. You can buy this type of memory in sizes up to 256 MB.

- **CompactFlash Type II** — This type of memory is almost identical to CompactFlash Type I memory. The only difference is that it is a little thicker, which allows it to store more information. You can buy this type of memory in sizes up to 1 GB.

- **SmartMedia** — This is the second most common type of memory used in digital cameras. It is a little smaller than CompactFlash.

- **xD-Picture** — A newer memory, which is very small and has a large storage capacity.

- **MemorySticks** — This is Sony's brand of SmartMedia memory. However, it only works with cameras that support MemorySticks.

EXAMPLES OF REMOVABLE MEMORY

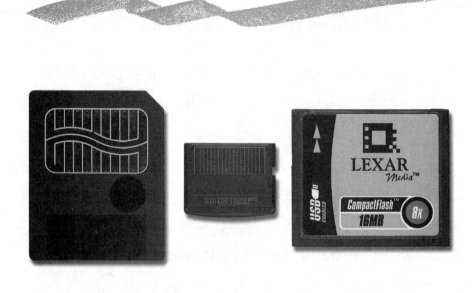

Photo 6: From left to right, 2 MB SmartMedia,
128 MB xD-Picture memory, and
16 MB CompactFlash Type I.

FIVE FACTS ABOUT REMOVABLE MEMORY

Below are five useful facts you should know about removable memory:

- Removable memory does not require *battery* power to safely store your pictures. If the batteries in your camera die, you will not lose your pictures.

- The different types of removable memory ARE NOT interchangeable. You cannot use SmartMedia in a camera that uses CompactFlash Type II.

- You can use CompactFlash Type I memory in CompactFlash Type II cameras. You CANNOT use CompactFlash Type II memory in CompactFlash Type I cameras.

- Do not keep any type of removable memory in the sun.

- Always turn off your camera before taking the removable memory out of your computer. This ensures that your camera is finished using it.

BATTERIES

A digital camera needs power to operate. Batteries are the power plant of a digital camera.

A digital camera performs many electrical functions and requires a lot of power. You can easily go through a set of batteries on a small picture-taking adventure.

Because digital cameras require so much power, you should consider using rechargeable batteries. Alkaline batteries do not last very long and you must throw them away after using them. You will pay more for rechargeable batteries in the beginning, but you will save money in the long run because you do not have to keep buying batteries.

If you choose to use rechargeable batteries, you also need to buy a charger. The type of battery charger depends upon the rechargeable batteries you use. Usually you buy the batteries and charger as a package.

Some digital cameras come with their own battery packs and chargers. Unless the camera's manual states you can use other types of batteries, do not use any other battery type in your camera other than the one supported.

WHAT IS THE MEMORY EFFECT OF RECHARGEABLE BATTERIES?

Before covering the different types of recharge-able batteries, be aware of one negative aspect of rechargeable batteries called *memory effect.*

If you do not completely drain a battery (use it until it is dead), it may not reach its maximum capacity during recharging. In essence, the battery forgets its maximum charge. And, the more often you recharge it, the worse this problem gets.

Why this occurs is due to the chemicals in the batteries. So when choosing a type of rechargeable battery you should consider if it is prone to memory effects.

WHAT ARE THE DIFFERENT TYPES OF RECHARGEABLE BATTERIES?

There are three common types of rechargeable batteries:

- **NiCad** — NiCad stands for Nickel Cadmium, and these were the first types of rechargeable batteries. These types suffer from memory effect as described. Because of this, we recommend you use NiCad batteries only as backups.

- **NiMh** — NiMh stands for Nickel Metal Hydride, and these are newer types of rechargeable batteries. Unlike NiCad batteries, these batteries do not suffer from memory effect. This means you do not have to completely discharge the battery before recharging it. However, on the downside, NiMh batteries slowly discharge while not in use.

- **Lithium-Ion** — If your camera came with its own battery pack, it probably uses Lithium-Ion batteries. These battery types have twice the power of NiCad and NiMh batteries. Unfortunately, you cannot buy rechargeable Lithium-Ion batteries in standard sizes like AA. Lithium-Ion batteries also require special re-chargers so you should only use the one provided or approved by your camera's manufacturer.

FIVE FACTS ABOUT BATTERIES

The following list provides some useful facts about batteries and digital cameras:

- Use only one type of battery at a time in your camera. Do not mix NiCad, NiMh, and alkaline batteries.

- Replace all the batteries at once.

- Like memory, the digital camera you buy dictates the battery type you can use. Be sure to check your owner's manual for the correct type.

- Remove the batteries from your camera when storing it. This will keep the batteries from damaging the camera.

- Most digital cameras use a standard size AA.

WHAT IS THE DIFFERENCE BETWEEN CCD AND CMOS CAMERAS?

Just as there are different types of memory and batteries, there are different types of digital cameras. Fortunately these differences have little impact on how you use your camera.

Two types of cameras exist: *CCD* (charged-coupled device) and *CMOS* (complementary metal-oxide semiconductor). The difference is in the type of image sensor the camera uses.

CCD cameras are sensitive to light and produce sharp images. On the downside, CCD cameras can also produce "halos" around lights and other bright objects such as reflections. CCD cameras also require a lot of power, which can quickly drain your batteries.

CMOS cameras produce better images that have sparkling highlights such as the shine off of a chrome bumper. CMOS cameras are also less expensive to manufacture than CCD cameras. They are also faster, that is, they write their images to memory faster than CCD cameras. CMOS cameras also use less battery power.

SHOULD I GET A CCD OR CMOS CAMERA?

Unless you are a professional photographer the differences between CCD and CMOS cameras are minuscule. Both types work just fine for amateur photographers.

You should weigh other features such as resolution, memory, battery life, etc. when making a decision about which camera to purchase.

WHAT IS THE LENS?

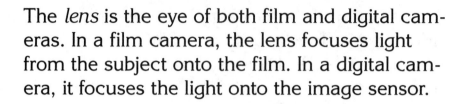

The *lens* is the eye of both film and digital cameras. In a film camera, the lens focuses light from the subject onto the film. In a digital camera, it focuses the light onto the image sensor.

The lens determines how well your camera sees its subject. As you might have guessed, the lens is an important part of a digital camera.

There are several types of lenses that you may find on a digital camera. Some have *fixed focal lengths* (see next section) while others have *adjustable focal lengths* called *zoom lenses*.

Most digital cameras have a permanently mounted lens with an adjustable focal length.

However, the more expensive, professional digital cameras have interchangeable lenses, which allow you to choose the best lens for the shot you are taking.

WHAT IS FOCAL LENGTH?

One important characteristic of a lens is its focal length. The *focal length* determines:

- How far or how close your subject appears in your picture.

- The *field of view* in your picture.

Focal length is measured in millimeters (mm). Some common focal lengths are 35mm, 50mm, and 135mm. On a film camera, the focal length is the distance from the center of the lens to the film.

This measurement is similar for a digital camera. The focal length is much smaller, typically 5–7mm. For the most part this measurement is meaningless. Therefore, manufacturers list the *focal length equivalent* for a lens on a digital camera. It is usually stated like: "5mm lens, equivalent to a 28mm lens on a 35mm camera", which means the lens, performs like a 28mm lens on a 35mm film camera.

If you want a 135mm telephoto lens, look for a digital camera with a 135mm lens equivalent on a 35mm camera. We use the focal length equivalent when referring to lenses.

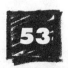

WHY IS FOCAL LENGTH IMPORTANT?

The focal length of the lens determines how close the subject appears and how much of the subject shows in the photo.

There are three categories of focal lengths: wide angle, normal, and telephoto.

Wide-angle lenses have a focal length less that 35mm, typically 28mm. You use a wide-angle lens to capture more of an image. You would use a wide-angle lens to make sure you get your whole family in a picture.

Normal lenses have a focal length between 35mm and 65mm. These lenses view an image much like a human eye views an image.

Telephoto lenses have focal lengths greater than 65 mm, usually between 75 or 135mm. Telephoto lenses take great close-up shots. You would use a telephoto lens to take a picture of your grandson's face as he played baseball while you were sitting in the grandstands.

WHAT IS FIELD OF VIEW?

Field of view is how much of your subject appears in the picture. Photos 7 and 8 (page 56) show an example of a wide-angle and telephoto shot of the same subject.

Notice that with the wide-angle lens more of the subject is in the field of view, but it appears far away. As the focal length is increased to make a telephoto lens, less of the subject is in the field of view, and it appears much closer.

FIELD OF VIEW EXAMPLES

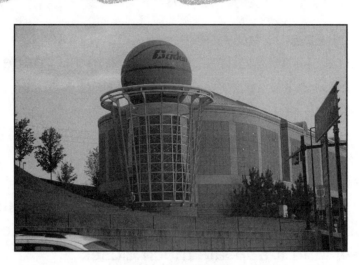

Photo 7: Picture taken with a wide-angle lens
showing a large field of view.

Photo 8: Picture taken with a telephoto lens
showing a narrow field of view.

WHAT IS ZOOM CONTROL?

Most digital cameras allow you to change the focal length of the lens. When changing the focal length you either zoom-in or zoom-out.

Zooming-in means changing the focal length to bring your subject closer to you, which narrows your field of view creating a telephoto effect.

Zooming-out means changing the focal length to move your subject further away. It widens your field of view creating a wide-angle effect.

The zoom control allows you to zoom-in and zoom-out.

For example, if you want to take a picture of a single bird at your birdfeeder, you will use your camera's zoom control to zoom-in on the bird. This allows you to get a close up of the bird from far away. If you want to take a picture of all the birds at your bird feeder you will use your camera's zoom control to zoom-out and see all the birds.

The zoom control is a button on your camera, usually marked with a W (wide-angle) and T (telephoto).

WHAT IS THE DIFFERENCE BETWEEN OPTICAL AND DIGITAL ZOOMS?

Digital cameras can have two types of zoom controls: optical and digital.

Optical zooms are identical to the zooms used on film camera lenses. That is, the focal length of the lens is changed when you operate the zoom control.

Digital zooms are often called the "poor man's" zooms. With digital zooms, the camera's computer approximates the focal length. In other words, it cuts out the part of the image that would have been removed from the field of view when you zoomed-in on your subject.

Most photographers prefer optical zooms as it gives a better representation of the subject.

WHAT ARE INTERCHANGEABLE LENSES?

Higher-end digital cameras, the *prosumer* or professional models, allow you to switch the lens of the camera.

These cameras resemble SLR (single lens reflex) film cameras. Once again, unless you are a professional or very serious amateur photographer, you probably do not need this feature.

WHAT IS THE FUNCTION OF A
LENS CONVERTER?

Depending upon your camera, you may be able to increase the capability of your lens with a *lens converter.* By adding a converter you are able to increase the apparent focal length of the lens. Typical converters are listed as 2X or 3X.

A digital camera that can use a lens converter has a threaded lens barrel. At the end of the lens you will find threads, just like on a nut. The lens converter screws into the end of the threaded-lens barrel.

You should check your camera's owners manual to see if it accepts a lens converter. Like most digital camera accessories, if you want to use a lens converter, you must purchase one designed for your camera.

WHAT IS THE SHUTTER RELEASE BUTTON?

The *shutter release button* causes the shutter
to open and close, which allows light to hit the
image sensor. The shutter release on a digital
camera operates just like the shutter release on
a film camera.

The shutter release button is usually located on
the top of the camera. Photo 2 (page 32) shows
the location of a shutter release button.

WHAT IS SHUTTER LAG?

On a digital camera a small time lag occurs between pressing the shutter release button and when the camera actually takes the picture. During this lag, the *autofocus* and *autoexposure* controls are calculating what to do.

Simply put, *shutter lag* can be annoying because it makes it hard to take action shots. You have to anticipate the lag before you take the shot. The same holds true if you take nature photos.

Shutter lags exist from 1/2 second to 1.5 seconds. As you might expect, the shorter the lag time, the more expensive the camera.

If you plan to take a lot of action photos, it might be worth the extra cost of getting a better camera.

WHAT IS AUTOMATIC FLASH?

Almost all digital cameras come with an internal automatic *flash*, controlled by the camera.

If the camera's light sensor determines that extra light is needed for the picture, then the flash fires when you press the shutter release button. An automatic flash makes it easy to take pictures in low light or dim areas.

More than likely you can disable your flash if you choose. This might be useful if you are standing in the shade and taking a picture of your family standing in the sun. Standing in shade makes the camera think it needs to provide extra light with the flash when it really does not need to.

Also, some cameras have a red-eye reduction flash. These types of flashes flicker, first, to get your eyes accustomed to the light, and then does a full flash when taking the picture. The flickering is very fast and you will hardly notice it. You usually have to set the camera to operate in red-eye reduction mode.

WHAT IS AN LCD?

The *LCD* is your camera's computer screen. It allows you to:

- Access the camera's menu to set up its features.

- To frame your picture on a "big screen" before taking the shot.

- Review the pictures you have taken before basic picture editing.

The quality of your camera's LCD screen is very important. You may want to consider a camera that has a big LCD with high resolution, or high pixel count.

You might also consider an LCD screen in which you can control the brightness. You might find the brightness of the LCD overwhelming when taking pictures in low-light scenarios.

The LCD screen consumes most of the battery power. If you do not use the LCD, you can take 4–5 times more pictures before draining the batteries.

Photo 4 (page 33) shows a digital camera's LCD.

WHAT IS THE CONTROL PANEL?

As you may have noticed by now, a digital camera has a lot of features. It has an electronic control panel that allows you to change how it operates.

Within the control panel, menus are used to change the camera's settings. The menus operate much like the menus on your computer or your television. Depending on your camera you might use the LCD to access the menu controls.

Referring back to the discussion on automatic flash, you can change the flash mode by using menus on the control panel. You can use the control panel to change exposure times, *shutter speeds*, and the self-timer.

Photo 2 (page 32) shows a digital camera's control panel.

WHAT IS THE VIEWFINDER?

The viewfinder is a "window" you look through to compose the picture. A viewfinder on a digital camera works the same way as a viewfinder on a film camera. Photo 2 and 4 (pages 32 and 33) show a typical viewfinder.

There are several types of viewfinders available on digital cameras. The simplest looks straight at your subject, while the more complex (and expensive) looks directly through the camera lens. The following describes the different viewfinders you will find on digital cameras:

- *Optical viewfinders* — These viewfinders look directly at the subject. They are also the most inaccurate because they are offset from the lens.

- *Electronic viewfinders (EVFs)* — Electronic viewfinders are small LCD screens that display the same information captured in the picture. An EVF can also display the menu controls so you do not have to remove your eye from the camera.

- *Through-the-lens (TTL) viewfinders* — A TTL viewfinder is the most accurate. Light passes through the lens, then into a series of prisms, and finally into the viewfinder. The image you see in a TTL viewfinder is what the lens sees.

Most professional cameras use TTL viewfinders.

Most cameras have a LCD on the body. It shows you what the lens is seeing. The LCD can perform two jobs. First, you can use it to compose your picture. Second, you and your subjects can use the LCD to review the picture you just took.

Remember, two types of viewfinders are available on most "point-and-shoot" cameras.

WHAT IS THE SELF-TIMER?

A camera's self-timer takes the picture after some short period. This neat feature allows you to take pictures of yourself!

How does it work? Just set the camera's timer then go jump into the picture. It normally takes between 3–5 seconds before the camera automatically snaps a picture.

You will generally need to use a *tripod*, or something else that can support the camera while you are in the picture. Also you will need to use the viewfinder to frame and focus the camera before starting the timer.

WHAT IS THE THREADED TRIPOD MOUNT?

Sometimes you may need to keep your camera absolutely still while taking a picture or you may want to support your camera when using the self-timer function. In both cases you should attach a tripod to your camera.

Most cameras have a threaded tripod-mounting hole located on the bottom of the camera. Just attach your tripod to the camera and you are ready to go.

DIGITAL CAMERAS — THE BOTTOM LINE

Digital cameras are versatile machines; and not to mention, the hottest thing going today!

What is the best digital camera on the market? It is hard to say. Everyday a new camera hits the market with new and better features.

Evaluate the features and controls, based on your own needs as a photographer. This will make it easier to determine the perfect camera for you.

Getting Set-Up

In this part we guide you through building a digital darkroom — a camera, computer, photo-editing software, and printer. We also try to identify the most important features to consider for each component and give suggestions to help you decide what is best for your needs.

HOW DO I GET STARTED?

Picking a camera may seem intimidating at first. After all, you need to learn a little about pixels, image sensors, etc. However, once armed with some basic information, you might find the process quite enjoyable.

If you bought a computer within the last year, chances are you have enough processing power to work with digital photographs. We give you some specifications that your system should have.

Most cameras come with basic photo-editing software. Windows XP has a basic photo-editor included with it. As with any hobby, you can always accessorize!

You might find buying a printer as confusing as picking a digital camera. However, if you consider yourself a casual photographer, then the choice is simple — buy a color *inkjet printer.*

To save some hassles, you can often buy complete systems: the camera, photo-editing software, and printer. This approach ensures that all your components will work together. If you don't want to spend a lot of time researching options, you should consider this route.

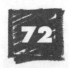

CHOOSING A CAMERA

So you have finally decided to buy a digital camera. Now comes the hardest part of all, choosing one!

There are digital cameras for all skill levels and budgets. Depending upon what type of photographs you want to take, you can spend as little as $50 or as much as $4,000.

Realistically though you can spend between $50–$500 for a good 3 or 4 megapixel camera, which will let you take photos more than suitable for emailing and printing. Spending more money buys more megapixels and features.

Photos 9 and 10 (page 74) show some typical digital cameras on the market. As you can see, you can choose from SLR-like, compact point-and-shoot, and miniature models. What you intend do with the camera determines the best model for you.

EXAMPLES OF DIGITAL CAMERAS

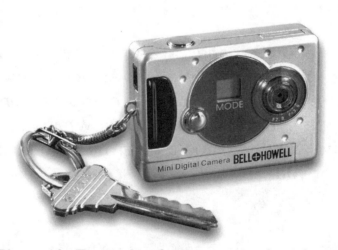

Photo 9: Examples of an SLR-like and
a point-and-shoot camera.

Photo 10: Example of a miniature digital camera.

PRIMARY USE OF YOUR CAMERA

Before buying a camera, think about how you intend to use it. This helps you to decide what features the camera needs to have. Here are some questions and answers to help you start thinking about it:

Q. Do I just want to take pictures and e-mail them to friends and family?
A. Yes, then buy a lower resolution (2–3 megapixels) camera.

Q. Do I want to take mostly outdoor photographs?
A. Yes, look for a camera with an optical zoom lens and an adjustable LCD.

Q. Do I want to let the camera do most of the work?
A. Yes, choose a digital camera that automatically controls the focusing, flash, and exposure.

Q. Do I want to print large, 8 x 10, pictures?
A. Yes, choose a camera with a pixel count of greater than 4 megapixels.

RESEARCH THE OPTIONS

Given the popularity of digital cameras, you should not have a problem finding information about them. In fact, there is a good chance you might find too much.

To begin your research we suggest using the Internet. Manufacturers of digital cameras have information about their products on their Web sites.

Independent Web sites dedicated to digital photography also exist on the Internet. These sites have camera reviews as well as how-to articles.

We list some useful digital photography Web sites in the Resource section in the back of this book.

Go to the local camera store. It always helps to hold a camera before purchasing one. You can also receive some personal attention and advice by shopping locally.

DIFFERENT CATEGORIES OF DIGITAL CAMERAS

When you start researching information on digital cameras, you will find they range in price from $50 to $8000.

To make it a little easier, we grouped digital cameras into different categories based on price. Besides the price, the cameras in each category share many of the same features.

Camera Category	Price Range
Consumer	$50–$400
Mid-range	$400–$900
Professional	+$900

CONSUMER CAMERAS

If you consider yourself a casual picture-taker, then you should look at consumer-grade cameras. These cameras work great for the "point-and-shoot" photographers.

Consumer-grade cameras typically have these features:

- Optical viewfinders.
- Fixed lens.
- Digital zooms.
- Permanent memory.
- 2–3 megapixel resolution.
- 1600 x 1200 image sizes.

Consumer cameras create pictures you can send in e-mails, post on Web sites, or print out 3 x 5 prints. Consumer cameras cost between $50–$400.

MID-RANGE CAMERAS

Mid-range cameras have a few more features that provide a little more flexibility when *composing* shots. If you consider yourself an advanced amateur photographer, look for a mid-range camera.

Mid-range cameras typically have some of the following features:

- Both optical and digital zooms.

- Removable memory cards.

- Digital viewfinders.

- 4 to 5 megapixel resolution.

- Automatic and some manual controls for adjusting the focus, *aperture* setting and shutter speed.

- 2560 x 1920 image size.

You can take a wide variety of photographs with a mid-range camera. Expect to spend $400–$900 for a camera in this category.

PROFESSIONAL CAMERAS

If you are professional film photographer look-
ing to leap into digital photography, you will want
to consider a professional-grade camera. These
cameras are the Cadillac's of digital cameras.

They take crisp, clear, pictures that rival single-
lens reflex (SLR) film cameras. In fact, some
professional cameras are SLRs that use an
image sensor instead of film.

Professional digital cameras often have the
following features:

- Through-the-lens viewfinders.
- Removable memory cards.
- Both optical and digital zooms.
- 6 megapixels resolution or greater.
- Interchangeable lens.
- 3624 x 2448 image size or larger.

As a professional photographer you likely have an
idea of what you want to do with the camera so
we won't cover that. When buying a professional-
grade camera expect to pay $900 or more.

MOST IMPORTANT FEATURES TO CONSIDER

Regardless of how you want to use a camera, there are several aspects of a digital camera that you should consider. These have a direct impact on the picture quality and the camera's ease of use.

- **Image Sensor** — Look for a camera with at least a 3 megapixel resolution. Anything less may take disappointing photographs.

- **Zoom Lens** — Always buy an optical zoom. Watch out, manufacturers may list the camera's digital zoom instead of the optical zoom.

- **Batteries** — If possible, choose a camera that uses standard AA size batteries. This lets you buy your own rechargeable battery system. Extra proprietary batteries can be expensive.

- **Memory** — If you take a lot of pictures, get a camera with removable memory, or a lot (128MB) of permanent memory. Removable memory is much more flexible though.

ADDITIONAL FEATURES TO CONSIDER

Besides the basic features to consider, you might want to look at some additional items that can make the camera easier to use:

- **Shutter Lag** — If you intend to take fast moving shots, like your grandkids riding bikes, get a camera with a shutter lag less than 1 second.

- **Size and Feel** — If possible, test several cameras before buying. Choose one that "feels" good in your hands. Some of the compact digital cameras feel small and fragile, while the larger ones feel bulky and heavy.

- **Accessories** — What type of accessories are available for the camera? You might not need a tripod or threaded-lens barrel now, but you may in the future.

- **Automatic Flash** — Having the camera control the flash is convenient. However, also look for cameras in which you can set the flash mode or turn it completely off.

WHAT KIND OF COMPUTER DO I NEED?

Your computer will be the center of your digital photography system. A computer with a fast processor and lots of RAM will make it easier to work with digital photos. Here are a few minimum system requirements your computer should have:

- **Processor Speed** — Pentium 3 or 4 for a PC; G3, G4, or G5 for a Macintosh.

- **RAM** — The more RAM the better. Anything over 256 MB should be adequate.

- **Hard Drive** — High-resolution pictures create large files, which can take up a lot hard drive space. Hard drives are inexpensive so make sure you have one with at least 40 GB of storage.

WHY IS RAM IMPORTANT?

More than anything else, the amount of RAM in your computer determines how easily you can work with digital photographs.

Why? Images are loaded into the computer's RAM as you edit them, so the more RAM, the more pictures you can edit at one time.

Also, the more RAM you have, the larger the photo you can edit. By larger, we mean size and resolution. Large photos, 8 x 10 or greater, and high-resolution pictures require a lot RAM.

The amount of RAM also impacts printing speed. When you print, the computer must convert the image to a format the printer understands. This conversion occurs in RAM. Some printers have the capability to do this processing. If you have a computer with limited RAM, you might consider one of these printers.

PC OR MAC?

Guess what? It really doesn't matter. Most digital cameras work with either PCs or Macintoshes. Just ensure that the camera comes with the correct cables to connect your camera to the computer, and the software is designed for your system.

The camera's box or specifications should clearly identify this information. If in doubt, don't hesitate to ask a salesperson.

Don't worry about the compatibility of the pictures. You can view the pictures on either a Macintosh or PC. Just look at the Web, you don't know if those Web site pictures were uploaded from a PC or Macintosh.

WHAT IS PHOTO-EDITING SOFTWARE?

Photo-editing software allows you to touch-up and print pictures. In general it lets you:

- Remove red-eye from people's eyes.
- Add text and captions to pictures.
- Adjust contrast and brightness.
- Soften and sharpen images.
- Enhance or change colors.

Some photo-editing software also lets you organize your photos. If you take hundreds of pictures a year then keeping track of them becomes a job! It can be tougher than managing a shoebox full of prints.

You can buy all different levels of photo-editing software. Most cameras include software with basic editing and printing capabilities. You can buy advanced and professional software at your local computer store or on the Internet.

CHOOSING PHOTO-EDITING SOFTWARE

Just like choosing a digital camera, you need to decide how you will use your software. As before, we provide you with some questions and answers that may help identify your needs:

Q. Do you only want to print and e-mail your pictures?

A. Yes. Use the software that comes with your camera. It allows you to download images from the camera and stores them on the computer for later printing or e-mailing.

Q. Do you want to adjust the contrast, sharpen lines, or add text to the pictures?

A. Yes. Buy a $50 photo-editing software package from the store to get all the touch-up features you need.

Q. Do you want to turn your pictures into works of art?

A. Yes. Purchase photo-editing software designed for graphic design professionals. Expect to pay more than $100 for software with advanced editing features.

ENTRY-LEVEL PHOTO-EDITING SOFTWARE

Entry-level photo-editing software gives you the tools to perform basic alterations to digital pictures.

Examples of things you can do with entry level photo-editing software include:

- Reduce the red-eye effect from people's eyes.
- Crop pictures to eliminate unwanted items from the edge of a picture.
- Adjust or change colors.
- Change color pictures to black and white.
- Adjust brightness and contrast to make pictures brighter or darker.

Most entry-level photo-editing software costs between $50 and $100.

Refer to the Resource section in the back of the book for a listing of the more popular photo-editing software packages.

ADVANCED PHOTO-EDITING SOFTWARE

Advanced photo-editing software is what the pros or ambitious amateurs use. This software allows you to radically change the way a digital photograph looks.

Some of the features in an advanced photo-editing software package include:

• The ability to do color separations before sending the print to a professional printer.

• Use both the RGB and CMKY color models.

• Create graphics optimized for web sites.

• Tools that allow you to adjust the image compression ratio to control file sizes.

Most advanced photo-editing software costs over $200.

Refer to the Resource section in the back of the book for a listing of the more printer manufacturers and their Web sites.

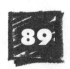

PRINTING OPTIONS

You have options when it comes to printing digital photos. You can print your own pictures or have a commercial service do it.

If you are like us, you will agree that digital photos are fun to look at on the computer, but it is still nice to have an old-fashioned printed photograph to hold in your hands.

These days there are plenty of inexpensive printers capable of producing great quality images.

CHOOSING A PRINTER

Like the other aspects of digital photography, knowing how you intend to use a printer determines what type of printer to buy. Here are some questions and answers to help you start thinking about your needs:

Q. Do you only want to create prints like those you get from a developer?
A. Yes. Choose a printer built for this purpose, often called a *photocentric printer.*

Q. Will you use the printer for other purposes, such as printing letters, more than creating prints?
A. Yes. Look for a printer that has good text and graphic capabilities.

Q. Is printing speed (pages per minute) important?
A. Yes. Look for a printer that prints quickly. However the price tag goes up the faster the printer prints.

THE PIXEL AND THE PRINTER DOT

A digital image consists of a specific number of dots, the so-called pixels.

Printers work with dots and the term dpi is used in reference to them. How big the dots are depends upon the manufacturer. In other words, all dots are not created equal.

WHAT IS PRINTER RESOLUTION?

Printer resolution is not the same as image resolution.

Printer resolution refers to how much ink the printer places on the page. It is measured in dpi. Usually, the higher the dpi, the better the resolution is. However, higher resolutions consume more ink and require more printing time.

Manufacturers produce printers in a wide range of dpi. You can find consumer models with resolutions of 72–2400 dpi. Just remember that more does not mean better.

You should take the dpi rating for a printer in stride. It's best to let your eyes do the judging. Go to your local computer store and see how well the printer prints.

WHAT IS HALFTONE PRINTING?

Halftone printing creates images using a series of screens or dots. They create an illusion of being a continuous image. You have to look very closely to see the individual dots of color.

Inkjet and laser printers use the halftone-printing method.

WHAT IS CONTINUOUS TONE PRINTING?

Continuous tone printing can create images with an almost unlimited range of colors or shades of gray. There is no separation between the color elements of the image, unlike halftone printing. You cannot see the colored dots in the same way as you can with a halftone image.

Dye-sublimation printers use continuous tone printing methods. This type of printer does not need to screen the image but rather can generate any color for each of the maximum of 300 printer dots.

CMYK — HOW COLOR PRINTERS PRINT COLOR

Printers use the *CMYK* color model. CMYK stands for Cyan, Magenta, Yellow, and blacK. Yes, K is used for black.

To create a color image, the printer combines one or more colors to create a new color. This is similar to what a painter does on his palette. For example, the printer combines cyan and yellow to create green. The more complex the color, the more colors the printer combines.

You should also be aware that most photo-editing software uses the *RGB* (red, green, blue) color model. Do not change the color model in the software. The printer's driver automatically converts the image to CMYK.

TYPES OF PRINTERS

Manufacturers produce several different types of printers that can print digital pictures. However, the output quality and operating costs vary dramatically.

Below are the types of printers most consumers use to create digital prints:

- **Inkjet Printers** — Affordable, versatile and produce good quality prints.

- **Laser Printers** — Fast and good quality. They cost much more than inkjet printers.

- **Thermal-Wax Printers** — Less versatility than an inkjet printer but produce very high-quality prints.

- **Dye-Sublimation Printers** — Very high quality, but cannot be used for printing documents. Photos are all they can print.

WHAT IS AN INKJET PRINTER?

If you want high-quality photos at a low price, and who doesn't, an inkjet printer does the job. You can create photos for only 2–10 cents a page.

Inkjet printers work by spraying tiny droplets of different colored ink onto the paper. Most inkjet printers have two or more ink compartments. The more compartments, the better the printer can blend colors to match subtle features like skin tone.

Some other facts about inkjet printers include:

- Inkjet printers tend to be slow. A large 8 x 10 color photo may take 5–10 minutes to print.

- Paper makes all the difference. Use high quality, glossy photo paper for the best, longest lasting prints.

- Photocentric printers create fantastic photos but often produce poor quality text and graphic documents.

WHAT IS A LASER PRINTER?

A color laser printer operates much like a photocopier. As a result it produces very high quality prints.

A laser printer is noted for its high-speed printing capability. It uses plain paper, which makes it inexpensive to operate.

The downside of a color laser printer is the initial cost to purchase one. Expect to spend more than $500 on a basic color laser printer.

WHAT IS A DYE SUBLIMATION PRINTER?

Like a photocentric inkjet printer, a dye-sublimation (dye-sub) printer is built only for printing digital pictures. Instead of spraying ink, dye-subs use ink ribbons of different colors. Dye-sub printers produce very high quality images.

A dye-sub printer also requires special paper for printing. The paper costs between $1 and $4 a sheet, depending upon its quality. As a result you only print "important" images with a dye-sub printer.

Unless you are an advanced amateur photographer and have a need for high quality prints, a color inkjet printer offers a better value.

WHAT IS A THERMAL-WAX PRINTER?

A thermal wax printer is very similar to a dye-sub printer, except instead of ribbons of ink, it uses sticks of colored wax.

In addition, just like a dye-sub printer, you must use special paper in a thermal-wax printer. It also only produces snapshot-sized images.

ADDITIONAL PRINTER FEATURES TO CONSIDER

Once you choose the type of printer you want, you can start looking at specific printer features to make printing easier. Below are some features to consider:

- **Camera-Printer-Direct Connect** — This feature allows you to connect your camera directly to the printer. If you want to print pictures without editing them first, then this feature is a must have.

- **Multi-function Printers** — Some printers now have fax capabilities. Consider one of these printers if you have a small home office.

- **Speed** — As mentioned before, color photographs can take a while to print. If patience is not your virtue, be sure to look at the speed ratings of a printer before purchasing it.

- **Borderless Prints** — Most printers cannot print all the way to the paper's edge. Some new photo printers can. If you want full 8x11 prints, consider a border-less printer.

WHAT IS THE BEST PRINTER FOR YOU?

To help you choose the best printer, here is a list of typical printer uses and the best printer for the job:

Q. Will you use the printer to print invoices, spreadsheets, or proposals for a home-based business and only occasionally print photographs?

A. Yes. Choose a general-purpose color inkjet printer.

Q. Do you need to print a lot of high-quality presentation graphics?

A. Yes. Choose a thermal-wax printer.

Q. Are you a serious amateur photographer that needs to produce very high-quality prints?

A. Yes. Choose a dye-sublimation printer.

Q. Do you need fast, low-cost per page printing for prints, graphics, and text?

A. Yes. Choose a color laser printer.

WILL MY PHOTOS FADE OVER TIME?

Like computers, printers have changed quite a bit in the last two years. Most printers built for digital picture printing produce prints that rival film pictures.

However, there is one problem. The prints do not last as long as prints created from film cameras. Why? Because light causes the colors to fade. The more intense the light (like sunshine), the quicker the print fades. Depending upon how you display your prints, the fading can begin within months or take several years. As you might expect, printer manufacturers are working to correct this problem.

Don't let this deter you from creating prints. As we mentioned, printing technology is changing so the problem will improve. Besides, you can always print the picture again!

PRINTERS — THE BOTTOM LINE

We recommend that you choose a color inkjet printer.

Inkjet printers are relatively inexpensive and produce very acceptable photographic prints.

You should expect to spend between $100 to $200 dollars on a quality printer. Anything above $200 has more features and faster print speeds.

Just remember, you MUST use quality paper to get great results with inkjets. In fact, you should buy high-quality paper produced by the printer's manufacturer. They often design their inks and paper to work together. You might pay a little more for the paper, but the quality is worth it.

GETTING STARTED — THE BOTTOM LINE

Digital photography is fun. The latest technologies make "going digital" easier than ever before. The best way to get started is by researching your options. Study this book. Make the switch to digital!

Choose a digital camera that fits your needs today and in the short term. Chances are that as you become more comfortable with digital photography, you will want to upgrade to a camera with more features. As technology continues to rapidly change we should see cameras with more features, at better prices.

Taking Pictures With A Digital Camera

In this part we present the basics of taking pictures with a digital camera using the viewfinders, focusing systems, automatic flashes, and exposure settings.

We try to identify the most important issues within each topic to help you start taking pictures right away.

This part won't make you an expert photographer, but it will help you take the first steps in becoming one.

CAMERA MODES: AUTOMATIC, PROGRAMMED AND MANUAL

Most digital cameras can operate in several different modes, which give you different levels of control. Depending upon your camera, you may have one or more of the following modes to choose from:

- **Automatic Mode** — This mode gives the camera complete control of everything, which includes the exposure and focus settings.

- **Programmed Mode** — This mode gives you some control over the camera. Depending upon your camera, you can control the shutter speed, focus, and aperture setting. Programmed mode is useful when you need to make some basic exposure adjustments.

- **Manual Mode** — This mode gives you complete control of the camera. Advanced amateur photographers often work in manual mode to create artistic effects in their photographs.

A camera in automatic mode functions just like a "point-and-shoot" film camera. In most cases, you will find automatic mode performs very well. In fact, you may never use your camera in a different mode!

WHAT ARE TEST SHOTS?

The wonderful thing about a digital photograph is if you mess up your picture, just take another shot. You are limited only by the number of photos that will fit into the camera's memory.

Tests shots allow you to experiment with different camera settings. If you fill-up the camera's memory, then erase some or all of your test shots and keep on experimenting.

The best thing about test shots is that they are free! So take as many as you want because the more pictures you take the better you will get. Who knows, a test shot might be your best picture.

USING THE SHUTTER RELEASE BUTTON

In automatic mode, most shutter release buttons operate like this:

- Press the shutter release button down halfway to let the camera set the focus and exposure.

- Continue to press the shutter release button down fully to take the picture.

Of course, all cameras operate differently so you should check your owner's manual for more details. Also check the owner's manual for details on programmed and manual settings in regard to the shutter release button.

IMPORTANCE OF KEEPING STILL

You should keep very still when pushing the shutter release button. Any movement can "confuse" the camera's autofocus system. Some cameras give you a warning when the camera is moving too much. Keeping still will ensure an in-focus picture.

Keeping still is especially important when taking telephoto or low light shots. Any movement can produce a blurred and unfocused picture.

We cannot stress the importance of keeping still while pushing the shutter release button. If you feel like you may have problems remaining still, we suggest using a tripod or *monopod*. Manufacturers now create lightweight, compact models that are easy to travel with and carry.

VIEWFINDERS AND LCD'S

You can use your camera's viewfinder or LCD to frame your subject and to see your cameras current settings. Some cameras use a small LCD as the viewfinder. In box-style cameras, all the viewfinder does is aim the camera.

When looking through the viewfinder or LCD you will find several pieces of information that help you take a picture. Figure 1 illustrates what a typical viewfinder or LCD shows. This viewfinder displays:

- **Focus Frame** — The small rectangle at the center of the viewfinder and is where the camera lens will focus.

- **Flash Indicator** — Tells you when whether or not the flash is on and in what mode it is operating.

- **Date and Time Stamp** — The date and time the picture is taken.

- **Remaining Pictures** — Shows how many more images you can fit on the current memory card.

- **Camera Mode** — Indicates if the camera is using automatic, manual, or programmed mode.

- **Zoom Bar** — Lets you know if you are in wide-angle or telephoto mode.

EXAMPLE VIEWFINDER

The following Figure shows the typical information displayed in a viewfinder or on a LCD screen. Check the camera owner's manual to determine what is displayed on your camera.

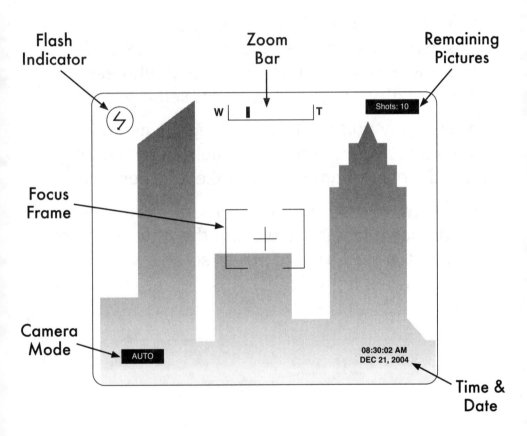

Figure 1: Typical information shown in a viewfinder.

HOW TO SET-UP AND USE AN LCD

Many people use the LCD to compose pictures because it is easy to see and work with. The following tips can help you get the most from the camera's LCD:

- You may have difficulty viewing the LCD when shooting outside or in bright areas. Most cameras allow you to adjust its brightness to make it easier to see in bright settings.

- You may find the LCD too bright when taking pictures at night or in dim light. If so, you can reduce its brightness to make it easier to see.

- You may notice that the camera's batteries run down faster when using the LCD. This tiny monitor uses a lot of power so be sure to turn it off when not using it.

TYPES OF FOCUSING SYSTEMS

Digital cameras come with one or more of the following focusing systems:

- **Fixed** — A fixed focus system is not adjustable so you cannot change how the camera focuses. Fixed focus systems work best when the subject is a few feet or more from the camera.

- **Autofocus** — The camera does the focusing for you. Most digital cameras use an autofocus system, which we cover in the next section.

- **Manual** — You must focus the camera lens. Most professional models have manual, as well as autofocusing systems.

Unless you have a specific need, we suggest using a camera with an autofocus system. It gives you more flexibility than cameras with fixed-focus lens and fewer hassles than cameras with manual focus systems.

USING THE AUTOFOCUS SYSTEM

A camera's autofocus system measures the distance from the camera to the subject. Based on the distance, the camera focuses its lens on the subject.

However, just because your camera does the focusing does not mean you do not have to do any work!

To make the autofocusing system work correctly, you must lock-in the focus before snapping the picture.

Holding the camera steady is a must for an autofocus system to work properly.

LOCKING-IN THE FOCUS

Locking-in the autofocus is fairly straightforward. Although all cameras work a little differently, they all follow a similar procedure:

- Using the viewfinder, place the focus frame on the center of your subject. The focus frame provides the focal point for the picture, or where the camera focuses the lens.

- Press, and hold, the shutter release button halfway down. The camera focuses the lens and adjusts the exposure.

- Once the camera sets the focus and exposure, it will beep or a light will flash. Next, press the shutter button all the way down to take the picture.

- Wait a couple of seconds for the camera to write the picture to its memory.

Try to remain as still as possible once you set the autofocus. Moving your camera may create a blurry or an out of focus picture.

It's a digital camera so if you don't like the picture, just take another shot!

USING THE FLASH

A lot of times you will take pictures in areas that require extra lighting. Fortunately, digital cameras have built-in flashes to provide extra lighting. Flashes on digital cameras operate like those on film cameras.

Most digital cameras also operate in an autoexposure mode, which means it adjusts the exposure settings for you.

In autoexposure mode the camera decides whether or not to use the flash to provide more light. You can also choose different flash modes to control the lighting.

Autoexposure mode is very convenient, but sometimes you want more control of the flash. If so, just change the flash mode.

WHAT ARE THE DIFFERENT TYPES
OF FLASH MODES?

You can use one of several different flash modes on most consumer grade cameras. The following list briefly describes each mode:

- **Auto** — The camera controls all aspects of the flash. You will likely use this mode most often.

- **Fill** — This mode sets the flash to fire regardless of the lighting condition. Use Fill Mode when the subject is backlit. This is usually when the subject is front of a bright light (like the sun). Backlit pictures look like the front of the subject is in a shadow. Using the Fill Mode puts light onto the subject so you can see it in the photograph.

- **Red-eye Reduction** — This mode fires a small, bright light just prior to the real flash, to let people's eyes adjust to the bright light of a flash. Use this mode when taking flash photos of people.

- **No-flash** — This mode turns off the flash. You will want to use this mode when taking pictures of objects that reflect light easily. We took Photo 1 (page 27) of the digital darkroom using the no-flash mode because the monitor reflected the flash.

THE BASICS OF EXPOSURE

Just like a film camera, a digital camera can create *overexposed* or *underexposed* photographs.

Too much light produces an overexposed photograph and it appears washed out. Overexposure usually occurs when taking pictures in bright light such as direct sunlight.

An underexposed photo has too little light and looks dark and grainy. Underexposure usually occurs when taking pictures in low or dim lighting.

Two factors determine exposure, shutter speed and aperture settings. The shutter speed controls how long the light hits the image sensor, and the aperture determines how much light hits the image sensor. We cover both of these factors in the next few sections.

WHAT IS SHUTTER SPEED?

Shutter speed determines how long light hits the image sensor by controlling how fast the shutter opens and closes. The longer the shutter stays open, the longer light can hit the image sensor. Digital cameras have shutter speeds ranging from 1/2000th of a second to as long as you want.

Generally, you use a faster shutter speed for action photos and a slower shutter speed for still photography.

In automatic mode, your camera will adjust the shutter speed for you. When you take pictures outdoors, it uses a fast shutter speed to let in less light. When you take pictures at night or inside, the camera uses a slower shutter speed to let in more light.

One thing to note, slower shutter speeds can also cause blurry photos. You need to keep the camera as still as possible when using slower shutter speeds.

Only some mid-range cameras and all professional cameras allow you to set the shutter speed of your camera. Check your owner's manual to be certain.

ADJUSTING THE SHUTTER SPEED

If you want to manually adjust the camera's speed you must place it in *shutter-priority mode.*

When in this mode, the camera allows you to change the shutter speed while it adjusts the other settings. You might consider using shutter-priority mode in the following ways:

- You may want to increase the shutter speed when taking outdoor photos or snapshots in bright light or action photos.

- You may want to decrease the shutter speed when taking indoor photos, snapshots in dim light, or scenery with not much moving in the frame.

WHAT IS AN APERTURE?

If you consider the lens is the camera's eye, then the aperture is the pupil. It controls how much light hits the sensor. Remember, the shutter speed controls how long light hits the image sensor.

In bright light, the aperture shrinks to let less light into the camera, just like your pupil becomes smaller to let less light into your eye.

In dim light, the aperture opens to let more light into the camera, just like the pupil becomes bigger to let more light into your eye.

Only some mid-range cameras and most professional cameras allow you to manually set the aperture of a camera. Check your owner's manual to be certain.

WHAT IS AN F-STOP?

An *f-stop* is a number that refers to the size of the aperture opening.

Oddly, a large f-stop number has a small aperture opening; and a small f-stop number has a large aperture opening.

Here are some general examples:

- An f-stop of 2, called f2, means the aperture has a large opening. This setting lets a lot of light hit the image sensor.

- An f-stop of 16, called f16, means the aperture has a small opening. This setting lets very little light hit the image sensor.

The largest and smallest f-stop settings depend upon the lens.

ADJUSTING THE APERTURE SETTING

If you want to manually adjust the camera's f-stop you must place it in *aperture-priority mode*.

When in this mode, the camera allows you to change the aperture while it still adjusts the shutter speed. You can use this mode to control the *depth of field* of a picture.

WHAT IS DEPTH OF FIELD?

Depth of field determines what part of your picture is in focus. (By what part, we mean how much in front of, and behind your focal point, is in focus.)

If most everything is in focus, then the picture has a large depth of field. If only the subject is in focus, then the photograph has a shallow depth of field.

Three factors control a photograph's depth of field:

- **Aperture Setting** — A large aperture opening (small f-stop) creates a small depth of field, while a small aperture opening (large f-stop) creates a large depth of field.

- **Lens Type** — A wide-angle lens produces photographs with a large depth of field. A telephoto lens will create a photograph with a small depth of field.

- **Subject Distance** — The closer the subject is the smaller the depth of field. Most close up photography — called *macro photography,* works with very small depths of field.

WHAT IS DEPTH OF FIELD?, CONT.

If you use a digital camera in automatic mode you need not worry about depth of field. You usually try to control the depth of field to create a special effect in your picture. In this case you need to work with the camera in a manual mode.

WORKING WITH SHUTTER SPEEDS AND APERTURE SETTINGS

You can completely control the exposure of a photograph by setting both shutter speed and aperture f-stop. On most cameras, you must use manual-mode to control these items.

Remember, the camera's shutter and aperture work together. As you increase one, the other must decrease. You are trying to balance how long light hits the sensor with how much light hits it.

Here are some suggestions for controlling exposures:

- If you decrease the shutter speed from 1/1000 of a sec to 1/10 of a sec, you must decrease the camera's aperture opening (choose a higher f-stop).

- If you increase the shutter speed from 1/10 of a sec to 1/1000 of a sec, you must increase the camera's aperture opening (choose a lower f-stop).

- Shutter speeds, shown in fractions of a second, range from slow, 1 second, 1/2, 1/4, 1/8, 1/15, 1/30, 1/60 sec., to fast, 1/125, 1/500, 1/1000 sec.

- If you increase or decrease the shutter speed by one setting, it halves or doubles the exposure respectively.

However, we recommend letting the camera do the work. That way you can concentrate on the shot, not the exposure. The camera will set the exposure correctly 99% of the time.

WHAT IS MACRO MODE?

A camera's *macro mode* lets you take very close-up photographs of small objects. In fact, some people call macro mode photography close-up photography. In macro mode, the distance between the lens and subject is measured in inches, not feet.

You see macro photographs everywhere. For example, close-up pictures of flowers, jewelry, and coins are taken with a camera in macro mode.

Focusing in macro-mode photography can be tricky due the aperture settings affect on the depth of field. Changing the f-stop, even slightly can cause the all or part of the picture to be out of focus.

Most digital cameras have a macro mode. Be sure to check your cameras owner's manual for details.

WHAT IS WHITE BALANCE?

Cameras with a *white balance* control allow you to fine-tune how "white", the color white appears in your photographs.

Interestingly, the color white looks different in different sources of light. For example, light from light bulbs give pictures an orange glow, and fluorescent lights give pictures a greenish-yellow tint.

To make the light source less of a factor you can use the white balance control. Consult your owner's manual for more details.

USING BURST MODE

When taking action shots, the shutter lag may cause you to miss some of the action. To combat this problem, digital cameras have what's called *burst mode*.

Burst mode rapidly fires two or more shots, within a very short time, when you press the shutter release button. Before using this mode you need to lock-in the autofocus because the camera doesn't refocus between shots.

Make sure you have enough room on your memory card to store the pictures as burst mode can shoot a lot of pictures very fast.

DIM OR DARK LIGHTING CONDITIONS

Eventually, you will find yourself taking pictures in dim rooms or other low-light settings. Digital cameras require more light than film cameras so taking pictures in these conditions may prove challenging. Follow these tips to get the best shots in low-light:

- Use the camera's autoexposure mode.

- Use a tripod or monopod.

- Turn on extra lights if indoors.

- Use the camera's automatic flash.

- Switch to aperture-priority mode and increase the aperture (lower f-stop setting, f2 for example).

- Ask the subject to remain very still if taking a portrait shot.

Do not judge the light setting by just looking at your LCD or viewfinder. In low light conditions, the LCD can appear normal to the eye, but the photo comes out underexposed if not using a flash.

TAKING PICTURES — THE BOTTOM LINE

Taking pictures with a digital camera is easy. You will likely find it very similar to taking pictures with a film camera.

When starting out, you will have the best results if you use the camera in automatic mode. This mode takes care of setting the camera's exposure and focus.

Working With
Digital Pictures

In this part we present the basics of working with digital pictures. We try to walk you through the process of getting pictures from your camera to your computer. We also cover some simple photo-editing topics.

WHAT IS A DIGITAL DEVICE?

A *digital device* is one that stores information digitally, that is, as a numerical value. The computer can then interpret that numerical value and play back great music from a CD, a movie from a DVD, or a photo from a digital camera.

A digital camera is just one digital device that you may want to hook up to your computer. Other digital devices that are related to your camera are card readers, printers, and storage devices. Check the next section on how to get these devices installed properly on your computer.

HOW DO I ADD A DIGITAL DEVICE TO MY COMPUTER?

Windows XP has a program that allows you to install all digital devices, including your digital camera.

XP contains drivers for most digital cameras. This means it can install the software without the need for a disc. If XP doesn't have the needed driver, you can always go to your camera manufacturer's web site and download it from there if a disk wasn't included with your camera.

To add a digital device using Windows XP:

- Select Start. Click on Control Panel.
- Click on Scanners and Cameras.
- Click on Add an imaging device.
- Click on Next.
- On the next page of the Installation Wizard, select the camera manufacturer and the model.
- If you have the disk that came with the camera, click on Have Disk button, otherwise click Next.
- Select Automatic Port Detection and click Next.
- Enter a name for your digital device and click Next.
- Click Finish.

HOW DO I GET MY PICTURES FROM THE CAMERA TO THE COMPUTER?

You download, or transfer, them. There are several different ways to transfer pictures from your camera to your computer. The details depend on your camera and computer.

Your camera may have a docking system that plugs into the computer. You can use an USB cable, a memory card reader (purchased separately), or a PC adapter card. There are even printers with memory card reader slots.

As mentioned, each camera interacts with the computer differently. Read your camera manual for more information.

WHY TRANSFER PICTURES TO
THE COMPUTER?

There are a couple good reasons to transfer your pictures to the computer.

First, because your camera is limited in the number of pictures it can store, you will need to move them so you can make room for more.

Secondly, once your pictures are stored on the computer you can edit, manage, print or e-mail them.

WHAT IS A DIRECT TRANSFER?

A *direct transfer* sends information back and forth between the camera and the computer through a direct cable connection (usually through a serial or USB cable that connects to the back of your computer).

The cable and software needed to perform direct transfers are usually provided with the camera.

If you transfer by direct cable, it is best to leave the cable attached to the computer so you do not have to sort through a snarl of cables each time.

One downside of this method is that your camera must be turned on for the transfer to work. You will be using battery power.

HOW DO I PERFORM A DIRECT TRANSFER?

- Check your battery levels.

- Make sure the software that came with your camera is installed.

- Read your manual and determine what type of connection your camera supports. Also, determine where the ports are located.

- Locate the cable that came with your camera.

- Connect the cable to the port on your camera and then to the corresponding port on your computer. (If you are using a serial cable, make sure the computer and camera are turned off when you connect the cable.)

- Plug in your power adaptor if you are in a place where you can use one. Otherwise, if you are using a standard serial cable, power up your computer and camera.

- Download your pictures from your camera.

- Power down to disconnect the serial cable.

- You can now erase the memory card in the camera.

WHAT IS A CARD READER?

It is a small electronic device that lets you insert a memory card into a slot and read it as a disk drive. It provides a continuously connected way to transfer images. It works the same way as the slot that reads the card in your camera.

Most card readers connect to your computer using an USB cable. One advantage is that you do not use up your camera batteries.

HOW DO I USE A CARD READER?

It's very simple.

- Install the driver software (included with reader).
- Connect the reader to your computer.
- Insert the memory card.
- Locate the extra drive letter that appears on your computer's main directory and click on it.
- Select the file you wish to download.

You can leave the card reader attached to your computer so it is always ready for you.

DOWNLOADING IMAGES USING WINDOWS XP

- Turn on your camera at the correct setting and connect it to your computer.

- XP recognizes the camera.

- Required camera software is automatically installed.

- Scanner and Camera Wizard opens.

- Check on the boxes to select images.

- Select a location for the images.

- Type a name for folder. Click Next.

- Click Finish.

VIEWING AND EVALUATING PICTURES

More than likely you cannot tell how good or bad your pictures are until you see them on the computer screen. You will have a chance to identify camera settings you may want to change once you review the photos.

Things to look for:

- Exposure problems.
- Color problems.
- Saturation and Contrast.
- White balance.

Make a list of settings to fine tune on your camera. Sometimes even the smallest adjustment can make a big difference.

HOW DO I ACCESS MY VIEWING OPTIONS?

To access your viewing options using Windows XP:

- Click on the Start button.
- Click on My Pictures
- Select View from the menu bar to see the available options:

 - **Filmstrip** — Displays pictures as a strip (like film negatives).

 - **Thumbnails** — A miniature reproduction of an image.

 - **Icons** — Displays images or folders as small icons, with the filename below them.

 - **List** — Displays images or folders as a list, with the filename next to them.

 - **Details** — Displays images or folders as a list, with file info next to them.

WHAT IS WINDOWS PICTURE
AND FAX VIEWER?

It is a useful tool for checking the color balance and focus of an image. It displays images at full screen size by just double-clicking on the image.

At the bottom of the Picture and Fax Viewer, there are a number of controls that allow you to browse through the images in the current folder. It allows you to zoom, change the orientation, save them to a disc, or send them directly to a printer. You can even delete them.

STORING AND ORGANIZING
DIGITAL PHOTOS

The best place to store your pictures, on your computer, is in the My Pictures folder. Windows uses the My Pictures folder as the default folder for image files. You can create subfolders within the My Pictures folder. Consider creating folders with meaningful names like "Christmas 2004" or "Ben's Birthday".

To create a folder:

- Click on Start.

- Click on My Pictures.

- Select File, New Folder.

- Assign a name to your new folder and press Enter to confirm it.

SHOULD I STORE PICTURES ON A
CD-R OR CD-RW?

Just like you filled a shoebox with film prints, if you take enough digital pictures you will fill up your hard drive.

You might find using recordable CDs a convenient, inexpensive way to store your images. In fact, they are the best choice for archiving images and transferring them to another computer. Here is some information on the two types of recordable CDs:

- **CD-R** (CD-Recordable) is a CD that can be recorded, once only, in a CD-writer. It cannot be erased or re-recorded. You may view the CD an unlimited number of times.

- **CD-RW** (CD-Rewritable) is a CD that can be recorded repeatedly, and used like a high-capacity floppy disk, in a CD-writer. Since it can be used more than once, there is a chance of erasing the pictures you are trying to save. Sometimes CD-RWs are not compatible with other CD drives.

HOW DO I SAVE PICTURES TO A CD-R OR CD-RW?

You'll need to have a CD drive capable of writing to a recordable CD. This drive is also known as a CD burner. Most new computers come with a CD burner.

You will also need to have blank CD-Rs or CD-RWs.

Follow the instructions that come with the CD burner and software. It's fast and easy.

HOW DO I DISPLAY PICTURES AS WALLPAPER ON MY DESKTOP?

To create wallpaper using Windows XP:

- Position your cursor anywhere in the desktop, except on an icon, then right-click.

- From pop-up menu, choose Properties. Select Desktop tab.

- Click on Browse. (The Browse box displays My Pictures directory by default). Locate the image you want to use, and then double-click it.

- Select the best option in the Position pull-down list.

- Click Apply.

HOW DO I CREATE A SLIDESHOW?

Using Windows XP:

- Ensure that all the photos you want in the slideshow are in one folder. You may move them, or copy them to any folder you care to.

- Click on Start.

- Click on My Pictures.

- Select folder you want to view as slideshow.

- In the Picture Tasks section (on the left side of the screen), Click on View as a slide show.

All of the files in the folder are displayed sequentially. You will have the option to manipulate the controls: Start, Pause, Move the Next/Previous image or Stop the slideshow.

HOW DO I ROTATE A PICTURE?

Most photo-editing software allows you to rotate an image 90-degrees clockwise or counterclockwise. If the image is completely upside down, just click one of the 90-degree rotation buttons twice.

Using Windows XP:

- Click on Start.
- Click on My Pictures.
- Click on the image you want to view.
- Click File.
- Select Rotate Clockwise or Counter-Clockwise.

WHAT IS COMPOSING AND CROPPING?

Composing is what you do prior to taking your photo. Frame the photo in the viewfinder or LCD, move toward or away from your subject, to fill the frame with what you want, and then take the photo.

Cropping is a way of removing or cutting-off the edges of a photo after you have taken the shot. Most photo-editing software provide this feature.

IS PICTURE-COMPOSING BETTER THAN PHOTO-EDITING CROPPING?

You get better results if you compose your photo when you take the picture. During shooting, you can move closer to the scene to fill-up the frame but you still have the same resolution when you press the shutter release.

Cropping reduces the size of the photo. A 3 x 5 photo may change to a 2 x 3 photo after cropping. You can increase it back to a 3 x 5, but the resolution will decrease.

CAN I ADJUST THE COLORS IN MY IMAGES?

Yes. Adjusting the colors is called *color balancing*. All imaging software allow you to increase or decrease the strength and intensity of the colors.

CAN I ADJUST THE BRIGHTNESS AND CONTRAST OF MY IMAGES?

Yes. Adjusting the brightness and contrast of your images can greatly improve their quality.

For example, Photo 10 (Page 158) shows a picture before we adjusted the brightness. Photo 11 is the same image after we increased the brightness. Notice how much more detail you can see after the adjustment.

EXAMPLE OF BRIGHTNESS ADJUSTMENT

Photo 10: A photograph before the brightness was adjusted.

Photo 11: A photograph after the brightness was adjusted.

ARE THERE SPECIAL FILE FORMATS FOR SAVING DIGITAL FILES?

Yes, there are many file formats available. It is not always easy to figure out which one to use. Some formats are manufacturer or program specific. Some are used to compress images and others mainly the Web.

Different file formats are better suited for some purposes than others, based on the size of files and the quality of images.

The most important file formats are: JPEG, GIF, TIFF, and PNG files.

WHAT IS A JPEG FILE?

JPEG is an acronym for Joint Photographic Experts Group. It is a format that allows for several levels of file compression from *lossless* (high quality, large file) to *lossy* (lower quality, small file). Compression shrinks the file size of your image.

Be careful when compressing images. Too much compression can degrade the image quality because pixels are thrown away when shrinking the file.

Another feature of JPEG files is that they can display over 16 million colors. The JPEG format is commonly used on Web pages or digital-camera files.

WHAT IS A GIF FILE?

GIF stands for Graphics Interchange Format. It is a lossless, compressed file format for image bitmaps originally created by the CompuServe on-line service to reduce download times for graphics. Although CompuServe created the file format, you can readily find GIF images on the Web.

The main disadvantage of GIF files is that they can only display 256 colors.

It is better not to save digital photos as GIF files because they do not look as good as JPEG's and they will be larger in file size.

WHAT IS A TIFF FILE?

TIFF stands for Tagged Image File Format. It is one of the most widely used and versatile formats.

When a file is saved to a TIFF format, a dialog box appears that allows you to specify whether you want to apply LZW compressions. In almost all cases it is a good idea to select this option.

WHAT IS A PNG FILE?

PNG stands for Portable Network Group. This is a fairly new file format. It uses 16 million colors and lossless compression.

It produces good image quality but a slightly larger file size. Currently, not all browsers support the PNG format.

HOW DO I KNOW WHICH FILE FORMAT TO USE?

Here are some things to consider when choosing a file format for your images:

- If you are storing finished pictures and you are pressed for space, use the JPEG format.

- TIFF format is good if you plan to do more work on your pictures.

- GIF format is good for logos, line art, and solid color images.

- You can compress files using a separate program to save space.

- Lossless compression does not change the file; however, lossy compression throws away some information causing the image quality to suffer.

- Most photo-editing software have their own file formats known as proprietary formats, into which they automatically save their files.

- You can save an image in more than one file format.

ADVANCED TECHNIQUES

Please remember that this book covers the basics of digital photography. There are plenty of good books available that talk about advanced techniques.

The best way to learn is to go out and take a lot of photos. Keep on pressing the shutter release. You will get the "hang of it" in no time.

Good luck! You can do it.

PHOTO-EDITING — THE BOTTOM LINE

One of the best advantages of using a digital camera is the control it can give you over your pictures. Even though there are some problems that no amount of photo-editing can fix, there are many that can be fixed. You can control contrast and brightness, color, size, and much more — it's entirely up to you.

PART 6

Publishing and Printing

In this part we focus on getting your pictures out of your computer and into the world so other people can see them. We cover topics such as e-mailing your photos to friends, posting your images on the Web, and printing them onto photo paper.

HOW DO I SEND PHOTOS BY E-MAIL?

Most of the popular e-mail programs give you two options for sending pictures. You can insert the photo in the body of the e-mail or attach the picture as a file to the e-mail.

When you insert the picture in the body of the e-mail, the picture is displayed when the recipient opens the e-mail.

To insert the file in the body of the e-mail:

- First, save a copy of your picture as a JPEG file at a low-resolution setting.
- Then set your e-mail format to HTML. (A few e-mail programs out there do not offer HTML format.)
- Open your e-mail program and create a message.
- Place the cursor where you want the picture.
- Click Insert, then click Picture, and then browse to the folder that contains the picture.
- Click OK to display the picture in your e-mail.
- Click Send to start the message on its way.

To attach the file to an e-mail:

- Open your e-mail program and compose an e-mail in the usual way.

- Select Attach (or click on icon that looks like a paper clip).

- Select a picture (Go to My Pictures or other folder you use to organize your pictures). Double-click on it.

- Click Send to start the message on its way.

CAN I E-MAIL MORE THAN ONE PICTURE AT A TIME?

Yes. However, remember to keep your image file size as small as possible. It is important to consider the format in which you are going to send them and the method the recipient is going to use to view them.

JPEG format compresses images to a smaller file size. Some e-mail systems set limits on the size of e-mail attachments that you can send.

Even if the recipient does not have a photo-editing program, they will still be able to view the picture via their Web browser, as long as the file is in GIF or JPEG format.

SHARING PICTURES ON THE WEB

Besides e-mailing your pictures as attachments, is there another way to share them? Yes, you can use the Web.

The advantage of Web sharing is that you eliminate the recipient's need to download, save, throw out, or do anything with the image. All they have to do is view the picture in a Web browser.

WHAT IS A WEB PORTFOLIO?

A Web portfolio is the same thing as a scrap-book, catalog, or photo gallery that gives you a thumbnail menu of your pictures. When you click on a thumbnail, you see an enlarged version of that photo.

You can put your portfolio on your own Web page or on a commercial sharing site.

CREATING A WEB PORTFOLIO

Displaying pictures on a Web site used to require hours of work. However, many software programs offer simple automated routines that make putting together portfolios for the Web very easy. All you have to do is specify the style template, image and text sizes, and a few more options and the program does the rest.

Adobe Photoshop and Photoshop Elements are two of the most popular photo-editing software programs available and include the tools to create a web portfolio. There are many books available about Internet and Web page creation.

SHARING SITES AND SERVICES

You can upload pictures to a photo-sharing Web site. Steps for uploading photos vary by site. Most sites offer photo-printing services as well as photo sharing.

To find a photo-sharing site, do a Google search. Go to www.google.com and type "online galleries" or "photo-sharing", or other similar key words.

CAUTIONS AND CONSIDERATIONS WHEN USING PICTURES ON WEB PAGES

Remember, the Internet is not private. Do not publish anything you do not mind the rest of the world seeing.

Do not publish people's last names or their addresses.

Check for embarrassing or offensive content.

PRINTING OPTIONS

You have many printing options. You can print your own pictures or have a commercial service print them.

Refer back to pages 90–105 for a short refresher on printers.

PRINTER SETTINGS

Printers can display color characteristics unique to the printer. You can adjust printer driver settings to fine-tune color. Drivers are the software that enable the computer to talk to the printer and vice versa.

Most printer drivers set the print resolution to low or medium. For the best quality, select the highest-quality setting.

You can optimize your printer settings when you select Print/Setup from whichever program you are using. Depending on the printer, you can select the paper type, speed, print resolution and other options.

IS PRINTING SPEED IMPORTANT?

Yes and no. Keep in mind, the larger the picture, the longer it will take to print. Usually, the better the paper, the slower the print speed. Higher resolution images also take longer to print.

INK CONCERNS

Ink Cartridges — Some inkjet printers come with special photographic ink cartridges. They can improve the quality of your pictures but are more expensive than regular ink cartridges.

When you change cartridges in your printer, make sure you realign the print cartridges. If the alignment is not perfect then this will affect the color of your printed photograph.

Fading — Pictures printed on an inkjet printer will fade over time. In direct sunlight, the fading process may begin in a few months. Always keep copies of your favorite pictures on your computer or backup device.

You can lengthen the lifespan of your pictures by spraying them with water-fast sprays available in art supply stores.

WHAT KIND OF PAPER SHOULD I USE TO PRINT PICTURES?

Selecting the right paper can be confusing. Even though papers may look similar, they come in varying textures and thickness.

If you want the best print results use a high-resolution printer, photographic-quality paper and a photographic ink cartridge.

Types of paper available include:

- **Plain Paper** — You would use this standard type paper in any copier or fax. It is versatile but is poor quality for pictures.

- **Inkjet Paper** — This paper is also known as coated paper. The result is a richer print. It is a step up from plain paper.

- **Photo Paper** — This paper is also coated, but the coating is much heavier. It comes in glossy, semi-gloss, and matte finishes. Matte finishes are the highest quality of photographic paper.

Make sure that you print on the coated side of the photo paper. If you print on the wrong side, the ink will be gooey and runny.

PRINTING USING WINDOWS XP WIZARD

- Click on Start.
- Click on My Pictures.
- Open a folder and Click on it.
- Go to Picture Tasks and Click on Print pictures.
- Click on Next on the first page of the Wizard.
- Check on the boxes to select images.
- Click on Next.
- Select printer and preferences.
- Select layout. Click on Next.
- Select Print.

PRINTING WITHOUT A COMPUTER

Some printers are equipped with special devices that accept direct printing from the camera, memory cards, or wireless communications.

Please check your printer manufacturer's manual for details.

PRINTING WITHOUT A PRINTER

If you have access to an Internet connection, you can send your images to online service centers, where they can be processed and printed to your specifications.

Some of the top sites are:

- www.snapfish.com
- www.photoworks.com
- www.shutterfly.com

Another option is in-store printing. Digital printing services can print images from most digital media, including camera memory cards, floppy discs and CD-ROMs.

PUBLISHING AND PRINTING —
THE BOTTOM LINE

More than ever before, digital photography offers lots of options for publishing and printing good pictures. Most of the equipment you need is inexpensive and easy to use.

You can share photos via e-mail or post them to your Web site; and it only takes a few minutes to produce prints, from your own printer, at any time.

1. "Point-and-shoot" digital cameras usually capture photos with image resolutions ranging from one to three megapixels.

2. Compact cameras usually offer a built-in flash and several scene modes, but few manual controls.

3. While resolution is directly related to how big a print you can make, it is not the only element in determining image quality.

4. Only Macintosh computers can read PICT files. If you intend to share files between a PC and a Mac, use TIFF or JPEG.

5. PCD stands for PhotoCD, a format designed by Eastman Kodak for transferring slides and film negatives onto CD-ROM.

6. After your pictures are on your computer, you can safely delete pictures from your memory card. To delete pictures, you should look for a menu option such as Format Card or, Delete Pictures.

7. A diffuser filter creates a light fog effect by using a soft focus. Color filters alter the color of your picture.

8. Printers connect to the computer using a serial or USB cable. An USB cable provides a faster connection than a serial cable.

9. Similar to film speeds, ISO settings on digital cameras indicate the digital image sensor's speed, or sensitivity to light. The higher the ISO, the more sensitive the sensor.

10. The camera aperture, controlled by a diaphragm mechanism, determines how much or how little light strikes the image sensor.

11. If you use more than one digital camera, it is a good idea to use the same memory type in each so you can interchange the cards.

12. Always return your camera to automatic mode before you move on to the next shooting location. You will then have the best chance of getting at least an acceptable picture when there is no time to prepare.

13. If you are focusing manually by the menu method, you will not be able to see focus corrections in the optical viewfinder. You will have to use the LCD.

14. Removable memory cards can be in the form of floppy discs, CompactFlash cards, XD Picture or SmartMedia cards. The type used

will depend on the type of camera.

15. When you put images on the Web, it is possible for anyone to download them and use them as they please. If you have a valuable image that you do not want copied, do not put it on the Web.

16. Each pixel represents a single color, so for subtle color changes it is best to have as many pixels as possible.

17. When calculating file size: 8 bits = 1 byte, 1,024 bytes = 1 kilobyte (1K), 1,024 kilobytes = 1 megabyte (1Mb), 1,024 megabytes = 1 gigabyte (1GB).

18. If you try to edit your pictures with a low-spec machine (i.e. 32 Mb of RAM and a 1 GB hard drive), you may find that it is a very slow process and your computer crashes regularly.

19. Some printer manufacturers such as Canon and Kodak produce printers that connect directly to their own digital cameras.

20. Some digital cameras come bundled with photo-editing software. In general, the more expensive the camera, the better the photo-editing program.

21. A digital zoom produces a lower-quality picture than an optical zoom.

22. If you open a JPEG image in your image editor, make certain that you save it as a TIFF file to prevent losing additional picture information.

23. While editing you can undo any adjustment by clicking the Undo button or you can reset all the adjustments you have made in the current session by clicking the Reset Image button.

24. To use a lens monitoring polarizing filter, view the picture you are going to take through the LCD monitor and turn the polarizing filter until you see the effect you want — then take the picture.

25. When you use specialty paper packages, be aware they do not supply extra paper for testing purposes.

26. The dot and pixel are not equivalent. A dot represents a single micro drop of ink. A pixel can be any of millions of colors. These terms are often misused.

27. Many e-mail providers place limitations on the file size of attachments. If the file is larger than 1MB, you may need to post it to a FTP server instead of sending it via e-mail.

28. Grayscale files cannot be colorized unless they are converted back to RGB.

29. The size of a file is set by the number of pixels in it. If it is compressed then it has fewer pixels in it and is subsequently smaller.

30. An 8Mb card can hold around a dozen images at the highest resolution and lowest compression, and 80 images at the lowest resolution and highest compression.

31. Check the battery life of your camera. Make sure that you use rechargeable batteries and a battery charger.

32. An optical zoom is an actual zoom; a digital zoom just crops the image in the viewfinder and then adds more pixels.

33. Viewfinders on digital cameras tend to have less information in them than film ones.

34. White balance is the term given to remedying indoor lighting problems.

35. If Windows XP does not recognize your camera, then it can be added as a new digital device.

36. If an image is viewed at a very high magnification, it becomes pixilated. This means you can edit individual pixels, which can be useful in reducing red-eye.

37. Always make a copy of an image before you start changing the size, color, or appearance. If the editing does not turn out as expected you still have the original to fall back on.

38. Most editing software has a Preview function when you are editing an item. This allows you to see the effect before you apply it to an image.

39. The size of your final image will be determined by your image resolution. This is set by the image editing software. Use 150–300 pixels per inch as a standard resolution with the photo-editing software.

40. Software for image processing and editing tends to require large amounts of RAM. As with processor speed, you cannot have too much RAM.

41. When making prints with your inkjet printer, be sure to set the printer setting for the appropriate paper type.

42. Make test prints to develop a sense of how the prints compare to your screen.

43. To control light's intensity and duration, you need to be able to control the aperture and shutter speed.

44. Aperture is like the pupil in your eye. It widens and contracts to control the amount of light entering the camera.

45. On a digital camera, the aperture is usually adjusted on the menu. The f-stop's lowest setting gives you the widest possible opening, admitting the most light.

46. While the aperture controls the amount of light that enters, the shutter speed deter-mines how long it is permitted to do so.

47. Fast shutter speeds will freeze moving tar-gets, in crisp detail; the more you slow the shutter speed, the more likely the same sub-ject will be rendered in a blur of movement.

48. Depth of field is the zone in front of and behind your focal point (usually the subject of the photo) that is in focus.

49. The most common way in-camera meters work is by measuring the amount of light in several areas seen through the viewfinder and then calculating the average value of the light.

50. Both CDs and DVDs are optical storage media. To record your photos, a CD writer or "burner" uses a laser, which etches a pattern onto the reflective underside of the disc in a long spiral format. The pattern can then be read by a CD drive using an optical sensor, which detects the encoded data.

DIGITAL PHOTOGRAPHY RESOURCES

Camera Manufacturers

1. Bell and Howell
 www.bellandhowell.com
 www.tinysnap.com

2. Canon EOS
 www.canoneos.com

3. Canon PowerShot
 www.powershot.com

4. Olympus, Inc
 www.olympus.com

5. Kodak Digital Cameras
 www.kodak.com

6. Nikon Coolpix
 www.nikon-coolpix.com

7. Sony Photography
 www.sonyphotography.com

8. FujiFilm
 www.fujifilm.com

9. Pentax
 www.pentax.com

10. Hewlett-Packard
 www.hp.com

11. Panasonic
 www.panasonic.com

12. Minolta
 www.minolta.com

DIGITAL PHOTOGRAPHY RESOURCES

Printer Manufacturers

1. Epson
 www.espon.com
2. Panasonic
 www.panasonic.com
3. Lexmark
 www.lexmark.com
4. Canon Bubblejet
 www.canon.com
5. Brother
 www.brother.com
6. Compaq
 www.compaq.com
7. Xerox
 www.xerox.com
8. IBM
 www.ibm.com
9. Apple
 www.apple.com
10. Sony
 www.sony.com
11. Hewlett-Packard
 www.hp.com

DIGITAL PHOTOGRAPHY RESOURCES

Photo-editing Software

1. Apple iPhoto
 www.apple.com/iphoto

2. Microsoft Picture It!
 www.microsoft.com/pictureit

3. Roxio PhotoSuite 7
 www.roxio.com

4. IrfanView (free)
 www.infranview.com

5. Microsoft Digital Image Suite
 www.microsoft.com

6. Adobe Photoshop Elements
 www.adobe.com

7. Jasc PaintShop
 www.jasc.com

8. Ulead PhotoImpact XL
 www.ulead.com

Useful Websites

1. **Digital Photography Review** — offers digital photography and imaging news, reviews of cameras and accessories:
 www.dpreview.com

2. **Imaging Resource** — reviews of digital cameras and scanners, side-by-side image comparisons, and tutorials:
 www.imaging-resource.com

DIGITAL PHOTOGRAPHY RESOURCES

3. **Steve's Digicams** — provides news and reviews on digital cameras, printers, scanners, camcorders, and software: <u>www.steves-digicams.com</u>

4. **Short Course in Digital Photography** — An online guide to digital photography: <u>www.shortcourses.com</u>

5. **Digital Camera Resource Page** — news and reviews on digital cameras: <u>www.dcresource.com</u>

6. **CNET Digital Cameras** — includes buyer's guides, tips and tutorials: <u>www.electronics.cnet.com</u>

7. **ZDNet Digital Camera Reviews** — reviews, recommendations and price comparisons: <u>www.zdnet.com</u>

8. **DCViews** — Detailed specifications, news, and reviews of digital cameras, tutorials, books, and tools: <u>www.dcviews.com</u>

9. **PC Magazine Digital Camera Guide** — buyer's guide and reviews: <u>www.pcmag.com</u>

10. **PCPhotoReview** — digital camera product reviews: <u>www.pcphotoreview.com</u>

11. **The Senior's Guide** — digital photography tutorials: <u>www.theseniorsguide.com</u>

GLOSSARY

adjustable focal length — a type lens that you can change its focal length from wide-angle to telephoto.

aperture — the "pupil" of a camera. It controls how much light hits the image sensor.

aperture-priority mode — a mode that lets you control the aperture's f-stop setting. The camera may still control the other exposure settings.

autoexposure — a system on a camera that controls the exposure settings, namely the shutter speed and aperture setting.

autofocus — a system on the camera that automatically focuses the lens on the subject.

battery — a cell that converts chemical energy into direct current. Most cameras use size AA or proprietary Lithium-Ion batteries.

burst mode — a camera mode that takes several photos very quickly without refocusing between shots. Useful for fast moving subjects such as sports.

CCD — Charged-Coupled Device, a type of image sensor used in digital cameras.

CMOS — Complementary Metal-Oxide Semiconductor, a type of image sensor used in digital cameras.

CMYK — Cyan Magenta, Yellow, blacK, the color model used by most printers.

color balancing — adjusting the colors in photo-editing software.

GLOSSARY

composing — arranging and framing your subject in the viewfinder.

cropping — remove the edges from a photo, which reduces its overall size.

depth of field — how much in-front and behind of the subject is in focus.

digital device — a device that uses digital (numerical) data that may be used by a computer. A digital camera is a digital device.

digital zoom — a type of zoom in which the camera's computer estimates the focal length of the lens.

direct transfer — the method of moving images from your camera to your computer by directly attaching them together with a cable.

dpi — Dots Per Inch, used to measure printer resolution.

electronic viewfinder — EVF, are small LCD screens that display the same information captured in the picture.

field of view — how much of the subject and its surroundings are captured in a picture.

fixed focal length — a type of lens that you cannot adjust its focal length.

flash — a device for providing extra light in low light scenarios. Most often the camera determines when to use the flash.

GLOSSARY

focal length — the distance from the center of the lens to the image sensor on a digital camera, or the distance from the center of the lens to the film on a film camera.

focal length equivalent — the equivalent focal length of a digital camera lens on a 35mm film camera.

f-stop — a numerical setting used to represent the size of the aperture opening. For example, f2 means the aperture is opened wide while f16 indicates the aperture is very small.

high-resolution — a digital image with a large number of pixels therefore showing a lot of detail.

image resolution — refers to the level of detail you can see in a digital image. See high-resolution and low-resolution.

image sensor — a photo-sensitive device that converts light into a digital image.

inkjet printer — a printer that creates text and images by spraying ink through tiny jets.

LCD — Liquid Crystal Display, a small computer screen on the back of the camera or in the Viewfinder.

lens — the "eye" of the camera, light passes through it before hitting the image sensor.

lens converter — a device you can use with your lens to increase its capabilities.

GLOSSARY

lossless — a term that describes the resolution of a file format. Refers to an image saved with zero pixel loss (no compression).

lossy — a term that describes the resolution of a file format. Refers to a compressed (some pixel loss), reduced-sized image file.

low-resolution — a digital image with a small number of pixels therefore showing small or moderate detail.

macro mode — a camera mode that lets you take very close-up photographs.

macro photography — taking very close-up pictures of objects.

megapixel — 1 million pixels.

memory — a device used to store, either permanently or temporarily, images or other data.

memory effect — a phenomenon that occurs in some rechargeable batteries where it loses its ability to be completely charged.

monopod — a support for a camera with only one leg. See tripod.

on-board memory — a type of memory permanently mounted in the computer. You cannot remove this type of memory from the camera.

optical viewfinders — a viewfinder that looks straight at the subject.

GLOSSARY

optical zoom — a type of zoom in which the physical focal length of the lens is changed.

output resolution — term used to describe the resolution of an image as you print it.

overexposed — a picture taken with too much light. The photograph will appear washed out.

photocentric printer — a printer designed for printing digital photographs.

pixel — the building block of digital photography.

pixel count — the number of pixels in a digital image.

pixel dimension — the dimension (width x height) of a digital image expressed in pixels. For example, 640 x 480.

prosumer — a very high-end digital camera with many features. However, it doesn't have all the attributes of a professional model digital camera.

RAM — Random Access Memory, erasable memory in your computer.

removable memory — memory, such as CompactFlash, that you can take out of your camera.

resolution — the level of detail you can see in a digital image. See high-resolution and low-resolution.

RGB — Red, Green, Blue. The color model used by most photo-editing software.

GLOSSARY

shutter lag — the time between pressing the shutter release button and when the camera snaps the photo.

shutter release button — a button on the camera that causes the shutter to open and close.

shutter speed — a setting that determine how fast the shutter opens and closes, which controls how long light has to hit the image sensor.

shutter-priority mode — a camera mode that lets you control the shutter speed while it controls the rest of the exposure settings.

through-the-lens (TTL) viewfinder — a viewfinder in which the light passes through the lens, then into a series of prism before being shown in the viewfinder.

tripod — a three-legged support used to steady a camera when taking a photo.

underexposed — a picture taken with too little light. The photo will appear dark and grainy.

white balance — a digital camera control that lets you adjust the impact of light on your photos.

zoom lens — a lens with an adjustable focal length.

INDEX

INDEX

INDEX

INDEX

INDEX

INDEX